"Gratitude is a soil on which Joy thrives."

–Berthold Auerbach

Mistakes can be frustrating but at the same time teach us valuable lessons about life and especially about ourselves. What mistakes have you made, that gave you an appreciation for the lessons they taught you?

*W*e are often too hard on ourselves and focus more on our failures than our victories. What are some of the victories you need to celebrate and be thankful for?

"Gratitude bestows reverence, allowing us to encounter everyday epiphanies, those transcendent moments of awe that change forever how we experience life and the world."

–John Milton

A Women's Gratitude JOURNAL

Follow us on social media!

Tag us and use #piccadillyinc in your posts
for a chance to win monthly prizes!

10 9 8 7 6 5 4 3 2 1

Printed in China

ISBN-13: 978-1-57133-578-4

"I am thankful for my struggle because without it,
I wouldn't have stumbled upon my strength."

–Alexandra Elle

Sometimes work can be overwhelming and feel like a big headache. At the same time, there are rewarding moments in the work we do. What are some things about your job that you're thankful for?

"For blessings ever wait on virtuous deeds,
And though a late, a sure reward succeeds."

–William Congreve

Our routines can feel monotonous or boring. Other times a routine can help you manage time and stay organized. In what ways has your daily routine added value to your life?

"*All human power
is a compound of time and patience.*"

–Honoré de Balzac

Weekends are a great way to unwind, relax, and spend time with family. What 3 things do you love most about weekends?

" Learn to wish that everything should come to pass exactly as it does."

–Epictetus

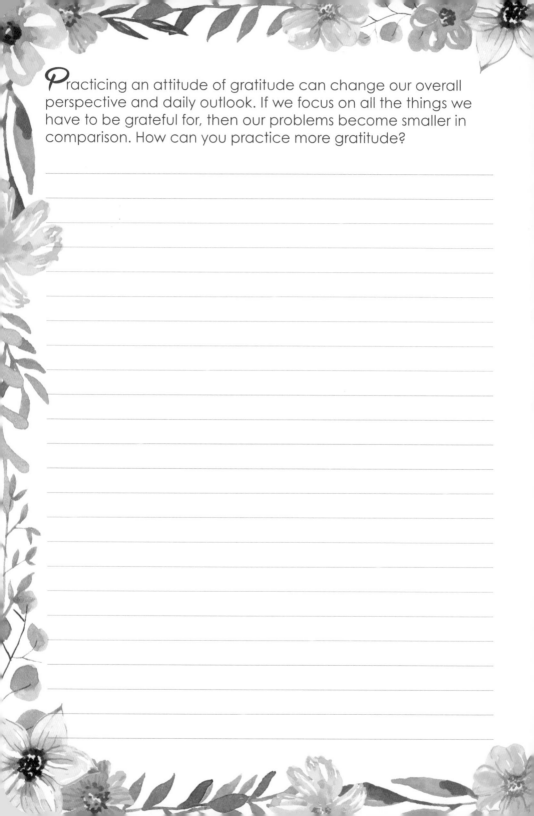

Practicing an attitude of gratitude can change our overall perspective and daily outlook. If we focus on all the things we have to be grateful for, then our problems become smaller in comparison. How can you practice more gratitude?

"Not what we say about our blessings, but how we use them,
is the true measure of our thanksgiving."

–W.T. Purkiser

*E*veryone has a favorite spot, their place of quiet retreat, or somewhere that makes them smile. Describe your favorite spot, how it makes you feel, and why you love it.

"Smiles are smiles only
when the heart pulls the wire."

–Theodore Winthrop

\mathcal{S}mall rewards we pamper ourselves with from time to time (like a new pair of shoes) are great ways to show self-love and reap the benefits of our hard work. What is your favorite way to reward yourself for a job well done?

"Work is not man's punishment; it is his reward,
his strength, his glory and his pleasure."

-George Sand

Coffee brewing, bacon frying, or fresh laundry hot out of the dryer are just a few scents from our daily life that can be so satisfying. What are a few things you look forward to smelling with joyful anticipation?

"*Gratitude is a soil
on which Joy thrives.*"

–Berthold Auerbach

Sometimes people can make a bad first impression but that doesn't mean they're a bad person. Bad days and circumstances can play a role in someone having an out of character moment. Who, when you gave a second chance to, made a better impression and why are you thankful you did?

"Chance happens to all,
but to turn chance to account is the gift of few."

−Edward Bulwer Lytton

*S*urprises are little unexpected bonuses in life that can brighten any day. Recall a few times you were pleasantly surprised and what it meant to you.

"To wake at dawn with a winged heart
and give thanks for another day of loving..."
-Kahlil Gibran

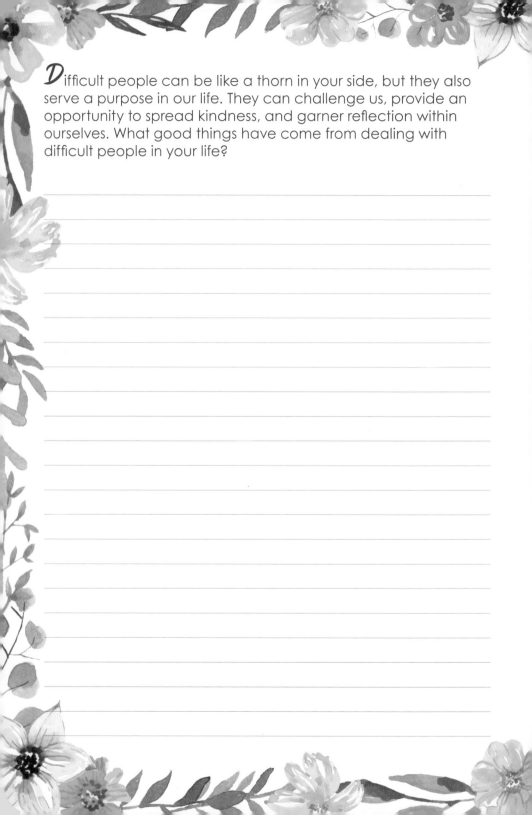

Difficult people can be like a thorn in your side, but they also serve a purpose in our life. They can challenge us, provide an opportunity to spread kindness, and garner reflection within ourselves. What good things have come from dealing with difficult people in your life?

"*Let the man, who would be grateful,
think of repaying a kindness, even while receiving it.*"
–Seneca the Younger

Compliments are verbal rays of sunshine we can spread throughout each other's lives. Write about the compliments you were most grateful to receive, how they made you feel and why they meant so much to you?

"The deepest craving of human nature
is the need to be appreciated."

–William James

*B*lessings remind us to be thankful and appreciative of the life we are given. What are your blessings and how do they make you truly grateful?

"To heal divisions, to relieve the oppress'd,
In virtue rich; in blessing others, bless'd."

–Homer

\mathcal{E}veryone has friends. But there's always that one special friend, the one who picks us up when we're feeling down, makes us laugh, and always has our back. Our best friend. Why are you most thankful for your best friend?

"We can only be said to be alive in those moments when our hearts are conscious of our treasures."

–Thornton Wilder

Colorful sunsets, beautiful flowers, and fluttering butterflies are just a few lovely things we can enjoy from nature. What things about nature are you most grateful for and why?

"Go to foreign countries and you will get to know
the good things one possesses at home."

-Johann Wolfgang von Goethe

We each have our own special gifts that make us unique. What are some of your individual gifts and talents that you're most appreciative and thankful for?

"Ought not every woman, like every man,
to follow the bent of her own talents?"

–Anne Louise Germaine de Staël

Describe a family member who you enjoy spending time with and what attributes you adore most about them.

"We would worry less if we praised more."

-Harry A. Ironside

Gifts are a fun part of life where people that care about us show their thoughtfulness with a token of appreciation. Write about an occasion where you were given a gift that meant everything to you and why.

"Some people grumble that roses have thorns;
I am grateful that thorns have roses."

−Jean-Baptiste Alphonse Karr

Technology, devices, and modern services make our lives easier and provide help to our hectic schedules. What advancements, gadgets, or services are you most thankful for and why?

"It's not easy to be a pioneer—
but oh, is it fascinating!"

–Elizabeth Blackwell

\mathcal{E}veryone sometimes deserves a second chance, but we don't always get one. Think about a time you got a second chance for anything, who gave it to you and what it meant to you?

"Wherever there is a human being
there is an opportunity for a kindness."
—Seneca the Younger

Photos are wonderful ways to capture our favorite moments, places and people. They are memories we can look back on and be transported in an instant. What photos warm your heart most and why are you grateful to have them?

"Far away there in the sunshine are my highest aspirations.
I may not reach them, but I can look up and see their beauty,
believe in them, and try to follow where they lead."

-Louisa May Alcott

*F*amily traditions are wonderful ways to preserve our heritage, stay connected to family members who are no longer with us, and to make new memories with our own family. What traditions do you cherish most and are thankful to have passed down to you?

"Gratitude is the memory of the heart."

–Jean-Baptiste Massieu

What are you most thankful for in your life right now? List at least 3 things below.

"Thankfulness is the beginning of gratitude.
Gratitude is the completion of thankfulness. Thankfulness
may consist merely of words. Gratitude is shown in acts."

–Henri Frederic Amiel

*S*ounds are all around us. However, there are certain sounds we value and they have a special place in our hearts—like birds chirping, laughter, or rain. What sounds give you the most joy?

"Nature seems to have implanted
gratitude in all living creatures."

-James Boswell

Expression is a way we celebrate our uniqueness and a chance to share ourselves with those around us. Some do it through fashion, body art, painting, etc. How do you express yourself and what way is most rewarding for you?

"As we express gratitude, we must never forget
that the highest appreciation
is not to utter words, but to live by them."

-John F. Kennedy

Little things in life can brighten our day like digging into a new book, a long soak in the tub, or an ice cream cone all to yourself. These treats give us something to look forward to every day. What little things in life do you look forward to each week?

"An effort made for the happiness of others lifts us above ourselves."

–Lydia Maria Child

Doing things for other people is great medicine for our souls. Putting a smile on someone else's face, cheering someone up, or even lending a helping hand can make our heart sing. What's the best thing you've ever done to brighten someone else's day and how did that make you feel?

"Our deeds determine us,
as much as we determine our deeds..."

-George Eliot

*H*aving something to look forward to helps us on the roughest of days. What are a few things you're most looking forward to in your life and how do you feel when thinking about them?

"The best way to show my gratitude is to accept everything, even my problems, with joy."

–Mother Teresa

We can sometimes take creature comforts for granted until we find ourselves in a position where we miss certain things from our home. A homemade meal, your favorite pillow, and even cable TV are just a few of the luxuries we can enjoy. What creature comforts are you most thankful for and why?

"Leisure will always be found by persons
who know how to employ their time;
those who want time are the people who do nothing."

–Madame Roland

*I*ndependence can be a great feeling. It gives us a boost of confidence that takes us to the next level of maturity in our lives. Think about a time you felt a sense of independence, what made you feel this way, and how much did it mean to you?

"Women are never stronger
than when they arm themselves with their weakness."

-Marie Anne de Vichy-Chamrond

*W*hat is your favorite holiday and what do you love about it most? What are some of the things centered around this holiday that make you grateful for it?

"If I only have the will to be grateful, I am so."

-Seneca the Younger

*I*f you had to pick one thing that you are thankful for daily, what is it, and what makes you so thankful for it?

"Saying thank you is more than good manners.
It is good spirituality."

–Alfred Painter

*W*hat about being a woman do you love and what attributes are you most grateful for?

"It is a woman's reason to say
I will do such a thing because I will."

-Jeremiah Burroughs

What type of writing do you love; poetry, short stories, biographies or fiction? Think about your most favorite book or author–write about what their work means to you and how it impacts your life positively.

"Simplicity is the most difficult thing to secure in this world; it is the last limit of experience and the last effort of genius."

-George Sand

*A*llowing yourself to have "me time" is an essential part of enjoying life. What is your favorite thing to do during your "me time." How does it help you and what do you get out of it the most?

"I am happy and content because I think I am."

-Alain-René Lesage

Think about the goals you've set for your life in the past and the ones you have yet to achieve. What is the most gratifying thing about accomplishing your goals and what do you look forward to the most about creating new goals?

"To accomplish great things, we must not only act,
but also dream; not only plan, but also believe."

–Anatole France

There's nothing like good conversation. Think about the best conversation you've had, who it was with, and what you talked about. How did it make you feel and what did you appreciate about the interaction most?

"Those who make us happy
are always thankful to us for being so.
Their gratitude is the reward of their own benefits."

–Madame Swetchine

\mathcal{S}elf-reflection is a great thing! You can learn a lot about yourself and learn to appreciate the individual qualities that make you unique. Wayne Dyer once said, "Remind yourself that you cannot fail at being yourself." What is the most rewarding part of self-reflection for you and how does it make you appreciate yourself more?

"Reflection is a flower of the mind,
giving out wholesome fragrance, But reverie
is the same flower, when rank and running to seed."

–Martin Farquhar Tupper

Change can be hard at times, but it can also be good for us, even rewarding. What big change have you made that you are grateful for and why?

"Blessed is he who has been able to
win knowledge of the causes of things."

-Virgil

*T*hink about your inner and outer beauty. What inner quality and outer feature are you most grateful for and why do you appreciate it?

"The power of finding beauty in the humblest things
makes home happy and life lovely."

-Louisa May Alcott

Nobody's perfect and we all have flaws; some flaws even keep us humble. What are some flaws you're thankful for and how have you benefited from them?

"A thankful heart is not only the greatest virtue,
but the parent of all the other virtues."

–Cicero

\mathcal{S}upport systems are great ways to tap into a network of helping people when we're feeling a little vulnerable. Religious centers, chat rooms, family members, and organized groups are just a few support systems. Where do you get support from, how does it help you, and how do you feel knowing you can depend on your support system in your time of need?

"Gratitude is a duty none can be excused from,
because it is always at our own disposal."

-Pierre Charron

Old wives' tales tell us "chicken soup is good for the soul." In fact, there's an entire book series dedicated to this idea. What is your "chicken soup" and what makes your soul feel good? Why are you thankful for it?

"Never does the human soul appear so strong and noble
as when it foregoes revenge, and dares to forgive an injury."

–Edwin Hubbell Chapin

*A*t some point in our life, we have all received advice–some good, some bad–but there's that one piece of great advice that can be life-changing. Who gave you your best advice, what was it about, and what did it mean to you?

"It is a pleasure appropriate to man, for him to save
a fellow-man, and gratitude is acquired in no better way."

-Ovid

\mathcal{S}tress is part of everyday life. But there are things we can do to combat that stress like yoga, meditation, and maybe even getting a massage. What is your favorite way to get rid of stress and how does it give you relief?

"In this world it is not what we take up,
but what we give up, that makes us rich."

-Henry Ward Beecher

Think about yourself and some of the unique traits that you have. What are your favorite "unique" traits about yourself and why are you grateful for them?

"He is a wise man who does not grieve for the things
which he has not, but rejoices for those which he has."

—Epictetus

\mathcal{H}obbies are an awesome way to spend time with ourselves or with people we like. Hobbies serve as an outlet to get our mind off our problems or simply to enjoy our life. What are your favorite hobbies, what do they mean to you, and how do they benefit your life?

"The essence of all beautiful art,
all great art, is gratitude."

-Friedrich Nietzsche

\mathcal{E}ach new day is a fresh start and can sometimes feel like a new beginning. What are a few of your favorite things about the start of a new day? What are you most grateful for about each new day you have to live your life?

"Thou that hast given so much to me,
Give one thing more—a grateful heart."

-George Herbert

Our passions can stir us up inside, give us purpose, and make our lives have meaning. Think about the things you are most passionate about–what do you love about them, why are you connected to them and how do you feel when you are pursuing your passion?

"We should employ our passions in the service of life,
not spend life in the service of our passions."

–Richard Steele

Food can be a big part of our lives. Desserts can make us smile, a homemade meal can comfort us, and extra sprinkles can make the world seem right. What is your favorite food to indulge in?

"Variety is the very spice of life."

-William Cowper

*T*hink about the seasons we have; spring, summer, autumn, and winter. What season do you connect with the most, what do you love about it, and why are you most grateful for it?

"To every thing there is a season,
and a time to every purpose under the heaven..."
-Ecclesiastes

*E*veryone deserves a splurge now and then. What recent splurge are you most thankful for and why?

"Enough is as Good as a Feast."

–James Howell

Think about the different experiences you've had in your life, good or bad. What two experiences in your life are you most grateful for and why?

"Blessed are those who can give without remembering, and take without forgetting."

-Elizabeth Asquith Bibesco

We have all had relationships that didn't work out as planned. Think about a relationship you had that didn't succeed. What did you take away from it, what did you learn about yourself, and what are you most thankful for with the outcome of this relationship?

"*A man cannot be said to succeed in this life
who does not satisfy one friend.*"

–Henry David Thoreau

We always hear about feel-good stories in the news or on social media. Think about a story you heard and how it touched you deeply, what was the story about, and why are you grateful for hearing it?

"Because all things have contributed to your advancement,
you should include all things in your gratitude."

–Wallace Wattles

*D*o you have a piece of jewelry that holds a special significance to you? What do you think about when you see this piece of jewelry, what does it mean to you, and how does it make you feel?

"*All which we behold is full of blessings.*"

-William Wordsworth

Sometimes we take things for granted. It can be a person, a position, or even a comfort in our life. What is something you used to take for granted but no longer do, and why do you value it more now? How did you become more grateful for what you used to take for granted?

"Unless we learn the lesson of self-appreciation and practice it, we shall spend our lives imitating other people and deprecating ourselves."

–Aida Overton Walker

We all have individual talents and sometimes we wish we had another person's talent. What about your special talents are you most grateful for? Write about how you use it to impact other people's lives positively and how that makes you feel.

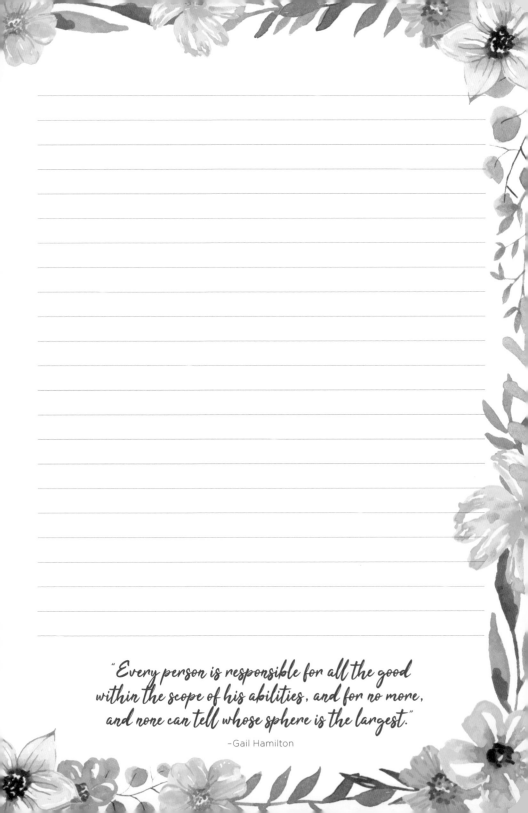

"Every person is responsible for all the good within the scope of his abilities, and for no more, and none can tell whose sphere is the largest."

–Gail Hamilton

Learning new things can be exciting, enrich our lives, and help us accomplish our goals. Think about something new you've learned. How did it change your life for the better and why are you grateful you learned it?

"You know I am not born to tread in the beaten track;
the peculiar bent of my nature pushes me on."

–Mary Wollstonecraft

What do you love most about the city or neighborhood you live in? Has it taught you anything, have you met interesting people and has it helped shape you into the person you are today? What are you most thankful to your city for?

"There is not more a pleasing exercise of the mind than gratitude.
It is accompanied with such an inward satisfaction that
the duty is sufficiently rewarded by the performance."

–Joseph Addison

Music can bring out so many emotions within us and it can also be the soundtrack to our life. What song is your "go-to" song for any occasion? Why do you like it and what are you most grateful to the song for doing for you?

"If the only prayer you said in your whole life
was "thank you," that would suffice."

–Meister Eckhart

Sometimes we meet a person who becomes our mentor, role model, and even in some special cases, our guardian angel. Who fills this role in your life and what are you most thankful to them for doing for you?

"*Appreciation is a wonderful thing:
it makes what is excellent in others belong to us as well.*"

—Voltaire

*I*t's easy to be proud of other people but seldom are we proud of ourselves. Write about something you did that made you proud of yourself.

"Grace was in all her steps,
Heaven in her eye, In every gesture dignity and love."
-John Milton

The kindness of strangers can often bring a tear to our eye and restore our faith in humanity. Holding the elevator open, the person in the drive-thru in front of us buys our lunch, or even strangers who help us in the most unexpected way. When have you experienced kindness from a stranger? How did it move you and impact you going forward?

"Blessed is the influence of one true,
loving human soul on another."

-George Eliot

\mathcal{S}ome people have a love/hate relationship with social media and other people can't live without it. What is your favorite thing about social media, how has it impacted your life positively, and why are you grateful for it?

"Remember that the responsibility of tolerance
lies with those who have wider vision."

–George Eliot

We don't like when people criticize us but sometimes we need to be open-minded about things we can improve. Constructive criticism can be beneficial if it is given with sincerity. What constructive criticism have you been given that had a positive impact on your life and why are you grateful to have received it?

"Ingratitude calls forth reproaches
as gratitude brings renewed kindnesses."

–Madame De Sevigne

What "chick flick" or woman empowering movie do you love? What do you love about it and how does it make you feel good?

"Honor women! They strew celestial roses
on the pathway of our terrestrial life."

–Pierre-Claude-Victor Boiste

Write about a time you were thankful to yourself, for pushing yourself to do something you didn't want to do. How did you feel going through this, what was the outcome, and how did it benefit you?

"Your bounty is beyond my speaking;
But though my mouth be dumb,
my heart shall thank you."

–Nicholas Rowe

Culture enriches our lives. Museums, artwork, concerts, and other festive events where people celebrate their talents, customs, and traditions are great examples we can appreciate. What culture or artistic avenues are you thankful for and how has it impacted your life in a positive way?

"*Gratitude is the fairest blossom which springs from the soul; and the heart of man knoweth none more fragrant.*"

–Hosea Ballou

We all have tough times and hardships in our life. They can test our endurance, inner strength, and willpower. What hardship have you gone through and you didn't know if you'd make it, but you came out on the other side like a shiny diamond? Why are you grateful for this trial?

"Do not let thunderclouds, however heavy their lurid piles, shut out from you the blue that is in your sky."

-Alexander Maclaren

What do you love about sunshine and how does it make you feel? Describe all the benefits you get from sunshine.

"You give but little when you give of your possessions.
It is when you give of yourself that you truly give."
—Kahlil Gibran

Keeping a childlike heart within us can be exactly what we need in certain situations. What brings out your inner child? Is it a swing set, a big bundle of balloons, or maybe a roller coaster? What do you love about feeling like a kid again?

"If nature is never bound down,
nor the voice of inspiration stifled, that is enough."

–Margaret Fuller

Our spirituality can be the cornerstone of our lives. Faith can be our place of quiet retreat, prayer, and meditation—or our best ally in the hardest of times. What are you most grateful for in your spiritual life?

*"Faith, however, is believing what you do not yet see;
to which faith the reward is seeing what you believe."*

–Saint Augustine of Hippo

\mathcal{H}ave you traveled to a special place that you immediately connected with? What trip or adventure have you taken that magically transformed your life?

"You traverse the world in search of happiness,
which is within the reach of every man;
a contented mind confers it on all."

–Horace

What accomplishment in your life has given you the biggest reward and the most satisfaction? Why does it mean so much to you?

"There are only two ways to live your life.
One as though nothing is a miracle.
The other is as though everything is a miracle."

-Albert Einstein

*D*o you have a favorite possession or family heirloom? Something that was given to you that has a bigger meaning than monetary? What is it and why does it hold such a significant place in your heart?

"Guard well within yourself that treasure, kindness. Know how to give without hesitation, how to lose without regret, how to acquire without meanness."

-George Sand

*W*hat healthy practices have you incorporated into your life that promotes a sense of well-being and mindfulness? How does it make you appreciate life more?

"No act of kindness,
no matter how small, is ever wasted."

-Aesop

What are you most thankful for being "you?"

"Knowing yourself is the beginning of all wisdom."

-Aristotle

What woman/women in history are you most grateful for and why? Whom do you feel paved the way for you to be who you are today?

"The woman who is resolved to be respected
can make herself so even amidst an army of soldiers."

–Miguel de Cervantes

*S*ilver linings can be great ways to look at cloudy days. Write about a bad day where you found a silver lining and why you're grateful for silver linings.

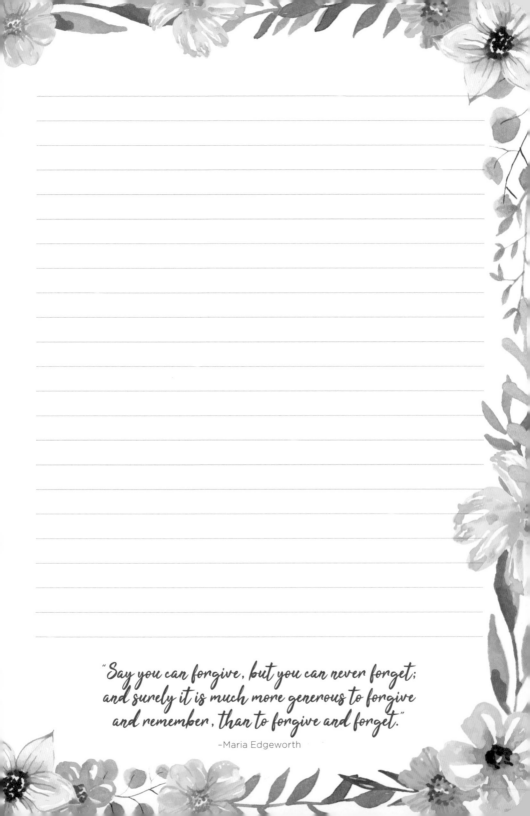

"Say you can forgive, but you can never forget;
and surely it is much more generous to forgive
and remember, than to forgive and forget."

–Maria Edgeworth

*S*uperpowers don't just belong to characters in comic books. If we look deep within ourselves, we each have our own unique superpower. What is your superpower and why are you thankful to have it?

"That possession which we gain by the sword
is not lasting; gratitude for benefits is eternal."

–Quintus Curtius Rufus

Colors brighten our lives and can instantly transform our mood for the better. What is your favorite color or colors, why do you love them, and how do they make you feel when you see them?

"An attitude of gratitude brings great things."

-Yogi Bhajan

*I*nspirational quotes are wonderful reminders and offer encouragement from people who have faced the same trials we have. What is your favorite inspirational quote, what does it mean to you, and how has it helped you?

"*Let gratitude be the pillow upon which you kneel to say your nightly prayer.*"

–Maya Angelou

*E*xercise and physical activity are great ways to keep in shape and it can also relieve stress. What exercise or activity do you enjoy most and why are you thankful for it?

"Appreciation can make a day—even change a life.
Your willingness to put it into words is all that is necessary."

–Margaret Cousins

Write about a few things you're thankful you had enough courage to do.

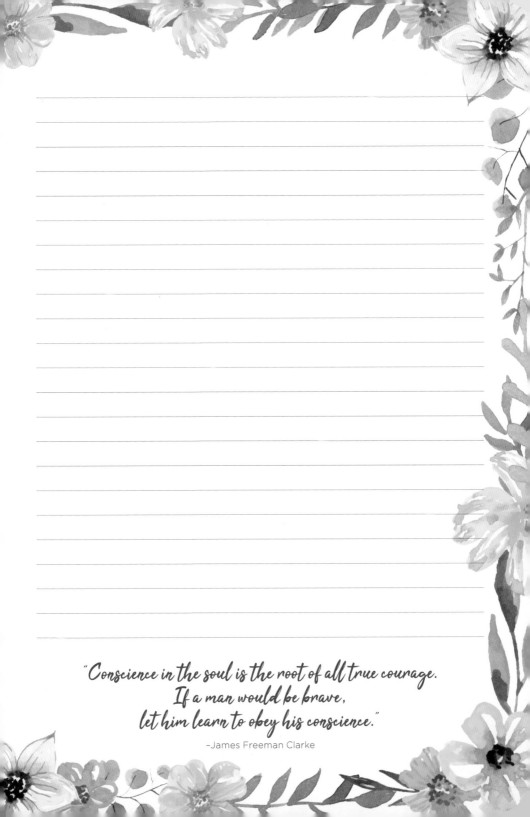

"Conscience in the soul is the root of all true courage.
If a man would be brave,
let him learn to obey his conscience."

–James Freeman Clarke

*B*irthdays are great reasons to celebrate. What was your most memorable birthday and what made it special? Why do you appreciate this particular birthday the best?

"*I awoke this morning with devout thanksgiving for my friends, the old and the new.*"

–Ralph Waldo Emerson

What 5 qualities or attributes do you have that you are most grateful for?

_"Gratitude is a nice touch of beauty
added last of all to the countenance, giving a classic beauty,
an angelic loveliness, to the character."_

-Theodore Parker

*H*ard work really does pay off. Write about a time you worked hard for something and how it made you feel. What positives in your life came from this hard work?

"If society will not admit of woman's free development, then society must be remodeled."

–Elizabeth Blackwell

Is there someone who makes your life better? Who are they, what do you love about them, and why are you thankful to have them in your life?

"Let us be grateful to people who make us happy;
they are the charming gardeners
who make our souls blossom."

-Marcel Proust

*W*hat was the sweetest text message you have ever received? Who sent it, what did it say, and how do you feel reflecting back on it today?

"She moves a goddess, and she looks a queen."

-Homer

\mathcal{O}ur dreams make us feel alive. They give us a sense of wonder, hope, and something to aspire to. What is your favorite dream for your life and how do you feel thinking about it? What dream in your heart are you most grateful for?

"For hope is but the dream of those that wake!"

-Matthew Prior

Animals make the world a better place simply by the cuteness they exude. Write about your favorite animal or pet, how they enrich your life, and make you feel satisfaction. Why does it mean so much to you?

"Animals are such agreeable friends;
they ask no questions, pass no criticisms."

–George Eliot

Write about the top 3 things you're grateful to have in your life when you're feeling down and why they brighten your day?

"Gratitude is a duty which ought to be paid,
but which none have a right to expect."

–Jean-Jacques Rousseau

*U*nexpected hugs, cuddles, and stolen kisses are just some of the signs of affection we get from friends, family, and loved ones. How do you express your affection and what is your favorite form of affection to receive from someone else?

"To live in hearts we leave behind is not to die."

–Thomas Campbell

Forgiveness is an important part of life. Forgiving ourselves and forgiving other people frees us from the bondage of hate. Why are you thankful for forgiveness?

"We forgive too little, forget too much."

–Madame Swetchine

*D*iversity is a part of life and it can be a great tool for learning if we submerse ourselves and celebrate the differences of each other. What do you love most about diversity, what have you learned from it, and why are you thankful for it?

"Man has his will, – but woman has her way."

–Oliver Wendell Holmes

Staying positive can be difficult but it can also be rewarding. It can shape our lives into something better if we choose to see the glass half full. What are your favorite things about positivity and what do you love about keeping a thankful attitude?

"A sound mind in a sound body, is a short
but full description of a happy state in this world."

-John Locke

Writing is a great way for us to express our thoughts and capture the moments of our life. What do you love most about writing and how does it add value to your life?

"Genius is essentially creative;
it bears the stamp of the individual who possesses it."

–Anne Louise Germaine de Staël

You've completed all the questions in this gratitude journal. How has writing and answering all the questions in this journal helped you? What have you realized about being grateful?